MINESCAPE

Brett Van Ort

Editors: Taj Forer and Michael Itkoff
Design: Ursula Damm
Copyediting: Sally Robertson

© 2013 Daylight Community Arts Foundation
Photographs © 2013 Brett Van Ort

ISBN 978-0-9832316-6-0

Printed in China

Daylight Books
E-mail: info@daylightbooks.org
Web: www.daylightbooks.org

"God has to nearly kill us sometimes, to teach us lessons."

–John Muir

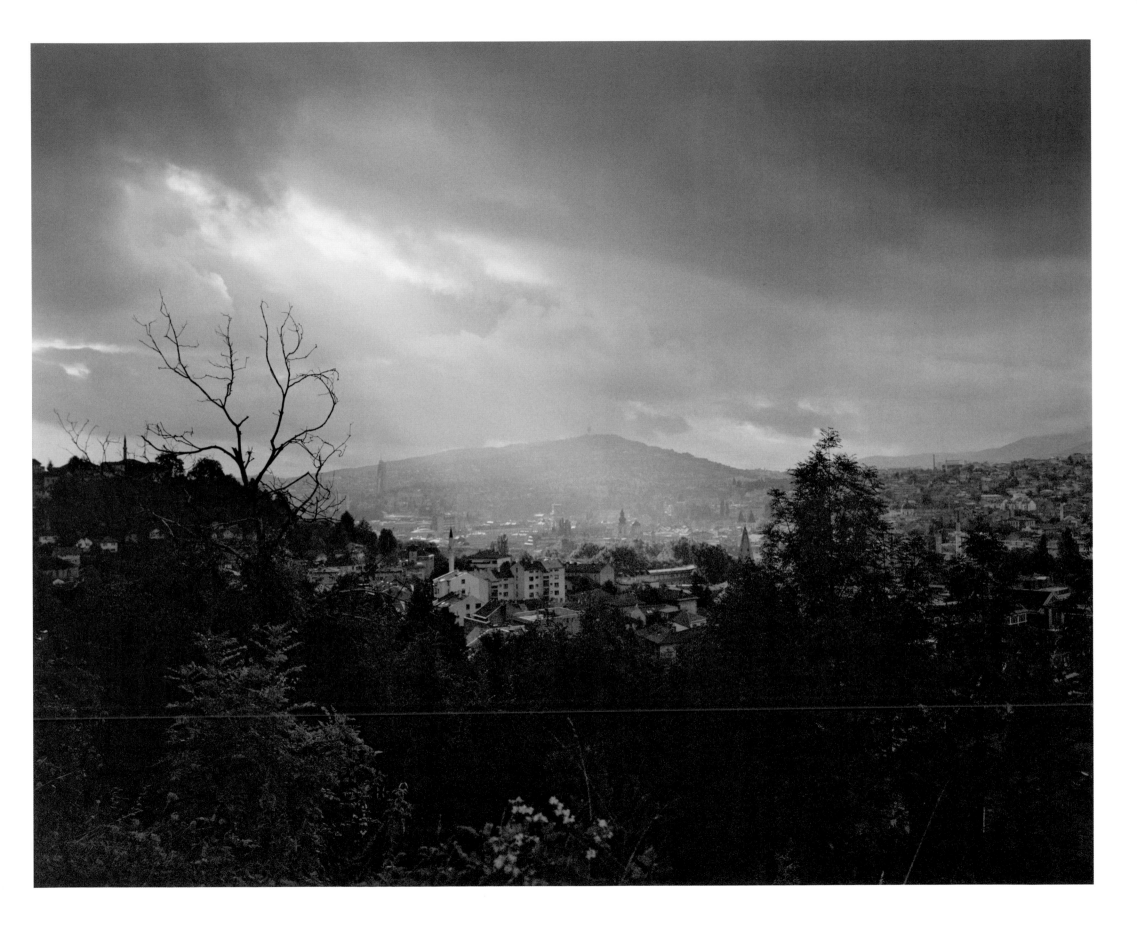

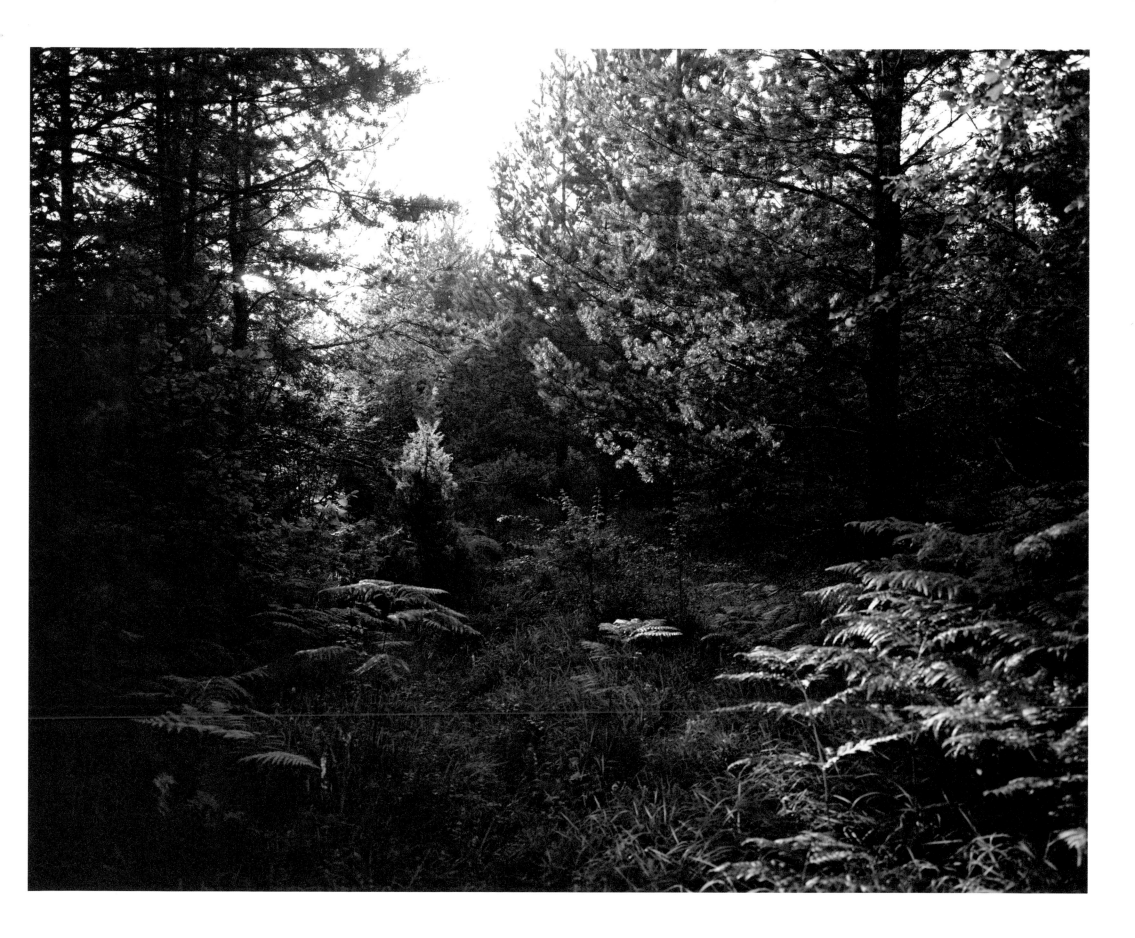

TMA-4

MINIMUM-METAL PRESSURE-ACTUATED ANTI-TANK MINE

MANUFACTURER: Former Yugoslavia

EXPLOSIVE CHARGE: 5,500 grams TNT

KILL RADIUS: 40 Meters

BLAST RADIUS: 100 Meters

APPROXIMATE COST TO PRODUCE: $10

NOTES:
Sufficient pressure on the top of any fuze breaks the fuze body, forcing the plunger into a friction-sensitive composition to create a flash, which initiates the detonator, booster, and main charge. The mine is a solid block of explosive with a thin plastic casing. A rope carrying handle is threaded through a hole in the mine body. This mine could be booby trapped using any of the range of former Yugoslav anti-handling devices.

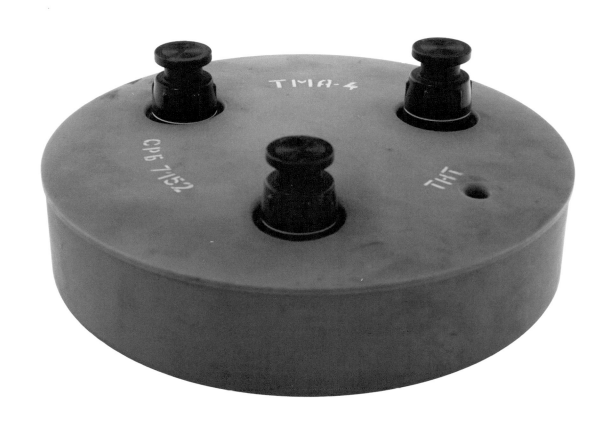

CONVENTIONAL BELOW-ELBOW PROSTHESIS

MANUFACTURER OF ARM: Various

MANUFACTURER OF HAND/HOOK: Steeper (UK)

LIFESPAN: 10 years

INTRODUCED: Early 1980s

APPROXIMATE COST TO PRODUCE: $4,500 with all accessories shown

NOTES:
Hook is controlled by a cable attached to opposite-side shoulder by a wire
providing user ability to close thumb when shoulders are brought forward.

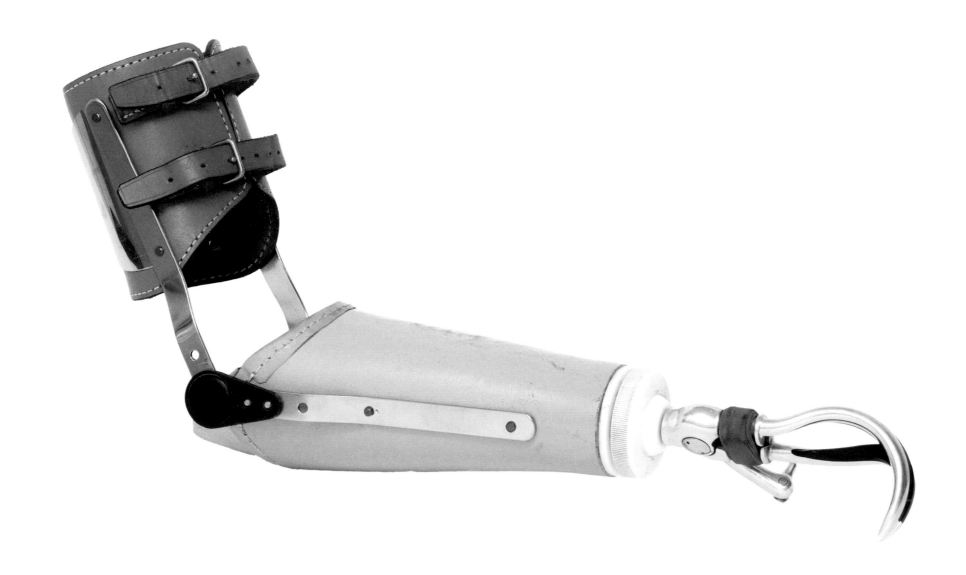

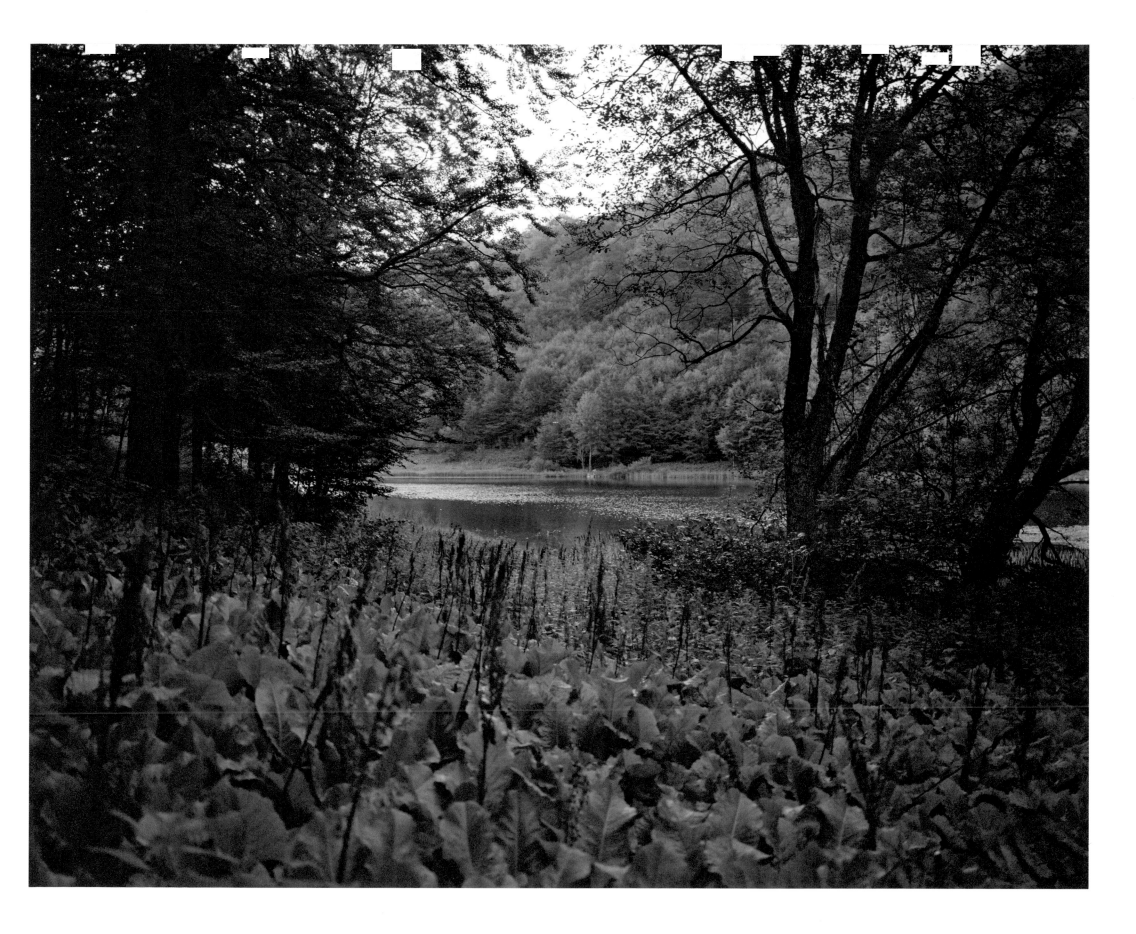

PROM

BOUNDING FRAGMENTATION ANTI-PERSONNEL MINE

MANUFACTURER: Former Yugoslavia

EXPLOSIVE CHARGE: 425 grams TNT

KILL RADIUS: 50 Meters

BLAST RADIUS: 100 Meters

APPROXIMATE COST TO PRODUCE: $8

NOTES:
Initiating the fuze ignites a propellant charge in the central tube, which blows off the base and propels the mine body into the air. The mine may be planted in water up to a half-meter deep. Highly dangerous. No attempt should be made to neutralize this mine unless absolutely necessary.

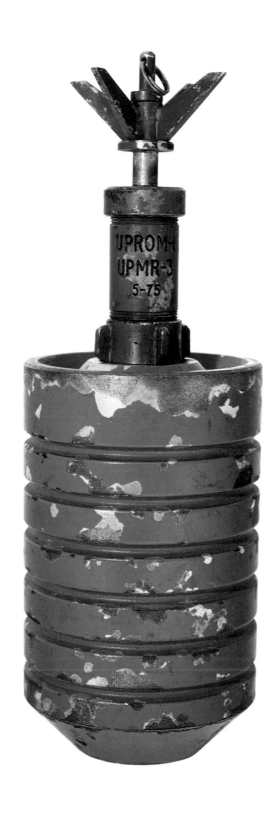

POLYCENTRIC PEDIATRIC KNEE JOINT

MANUFACTURER: Össur (USA/Canada)

LIFESPAN: 5 years

APPROXIMATE COST TO PRODUCE: $1,440

NOTES:
Maximum patient weight of 100 lbs. Two spring selections for extension
assist (Yellow=Regular, Blue=Firm).

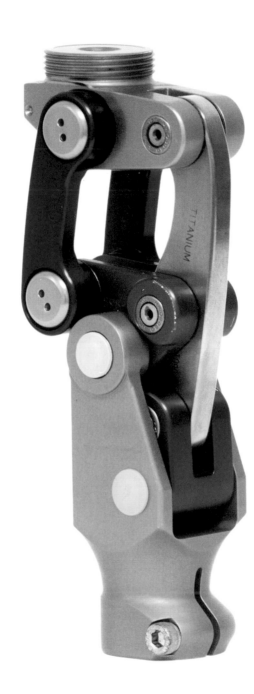

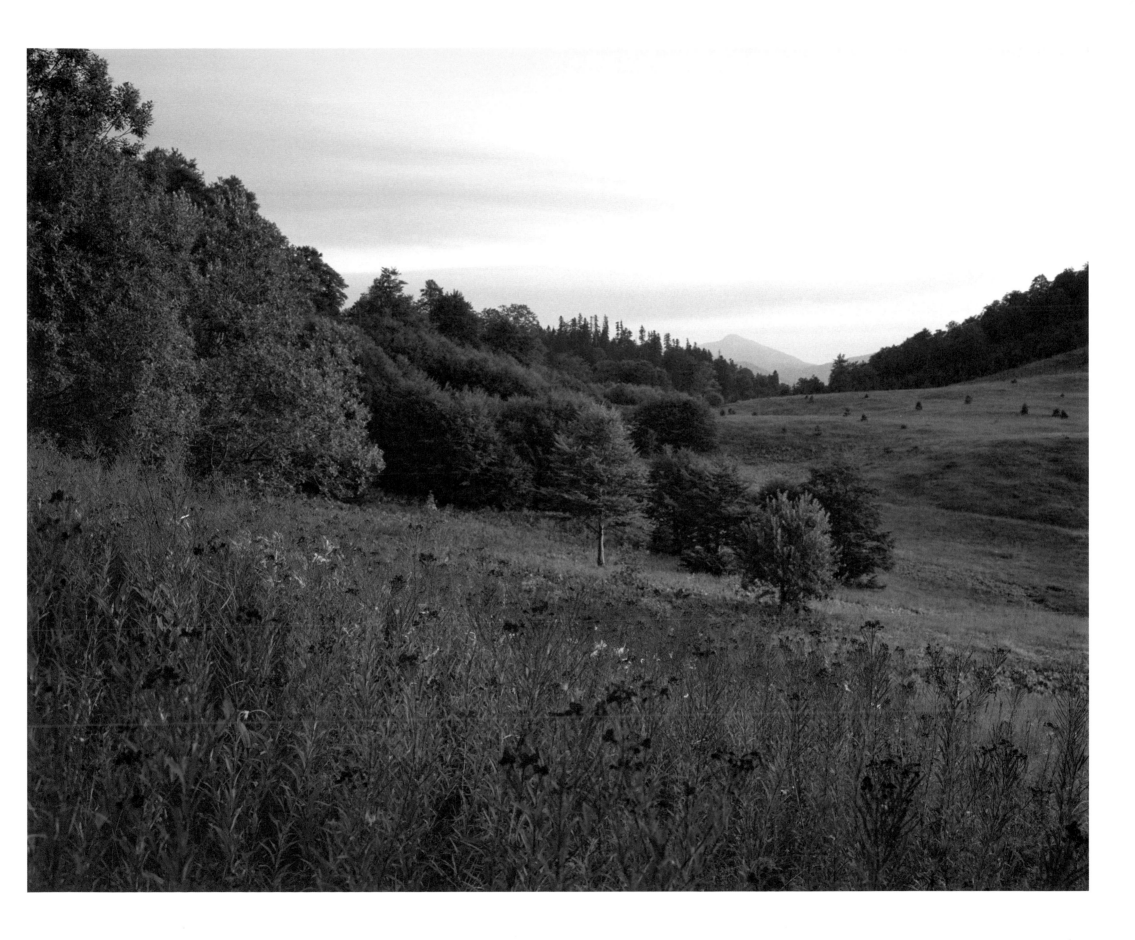

MRUD

SURFACE-LAID DIRECTIONAL FRAGMENTATION ANTI-PERSONNEL MINE

MANUFACTURER: Former Yugoslavia, Based on U.S. Claymore Mines

EXPLOSIVE CHARGE: 900 grams Plastic Pentrite

KILL RADIUS: 50 Meters

BLAST RADIUS: 300 Meters

APPROXIMATE COST TO PRODUCE: $5

NOTES:
A single layer of 650 steel balls, each 5.5 mm in diameter, is enclosed in a plastic liner set across the inside of the front of the mine. On initiation, the steel balls create a lethal arc of 60° for 50 meters in front of the mine. Detonation achieved via electric firing cable or tripwire activation.

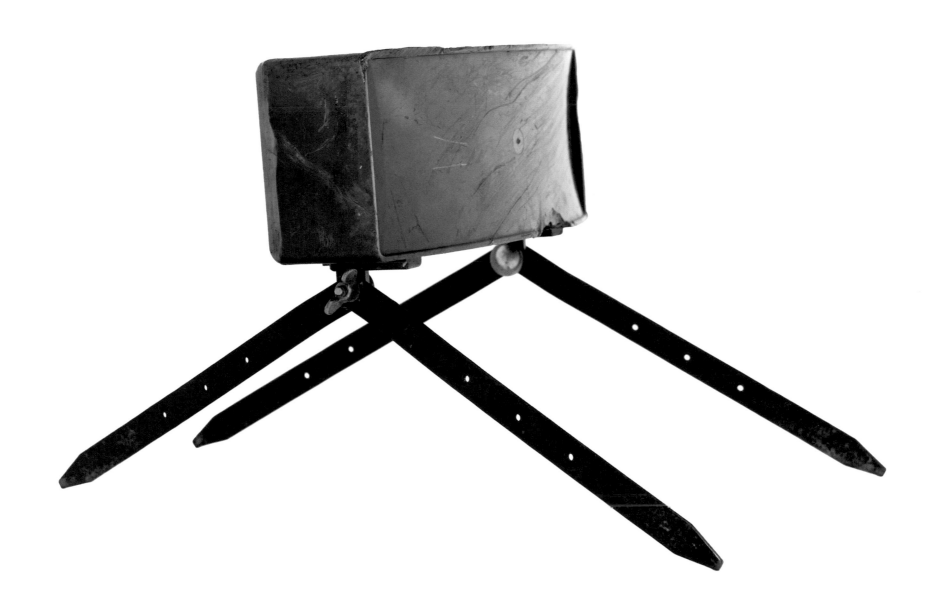

BELOW-KNEE LIGHTWEIGHT PROSTHESIS

MANUFACTURER: Combination of parts from Ottobock (Germany)
and Steeper (UK)

LIFESPAN: 5 years

APPROXIMATE COST TO PRODUCE: $4,000

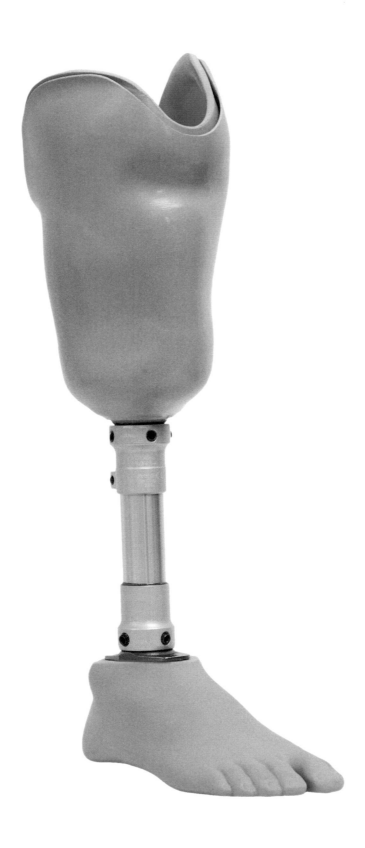

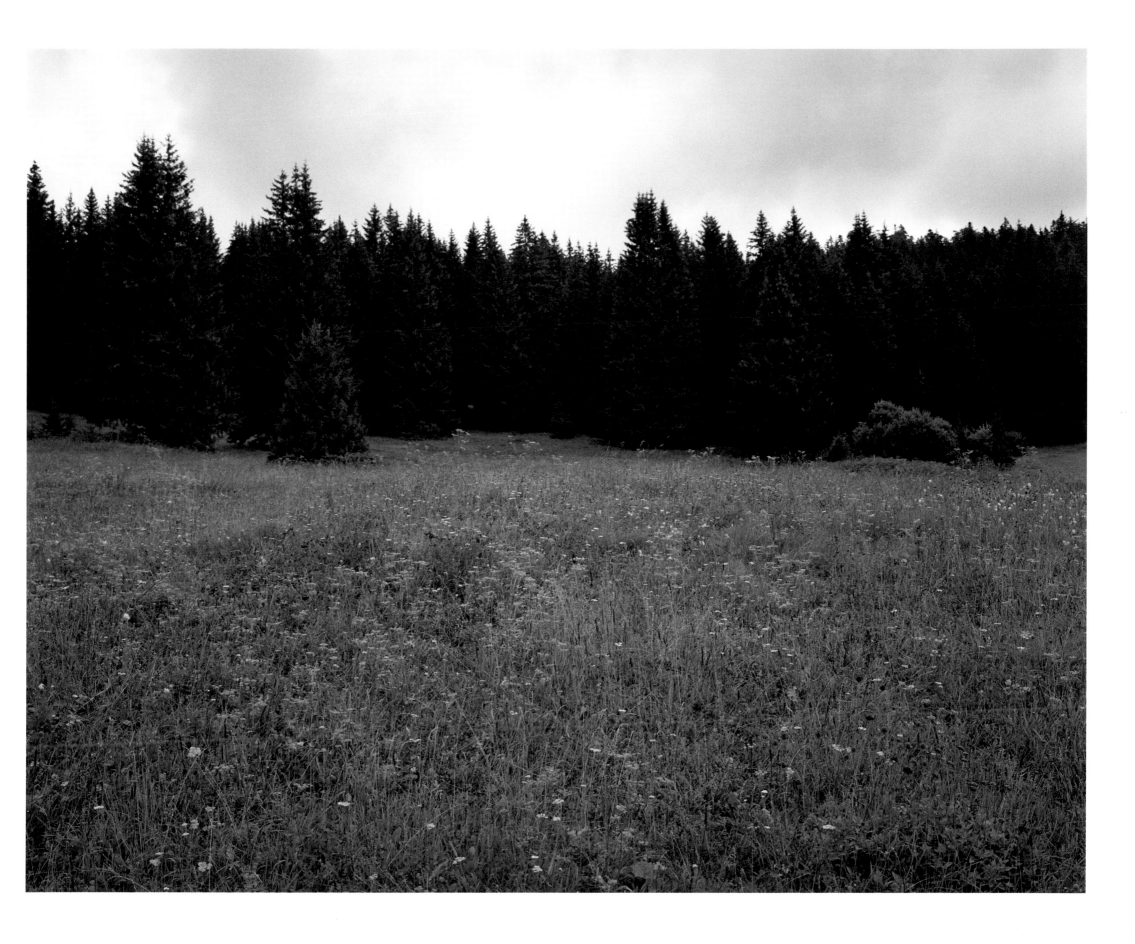

PMR-2A

TRIPWIRE-ACTIVATED ANTI-PERSONNEL FRAGMENTATION STAKE MINE

MANUFACTURER: Former Yugoslavia

EXPLOSIVE CHARGE: 100 grams TNT

KILL RADIUS: 25 Meters

BLAST RADIUS: 50 Meters

APPROXIMATE COST TO PRODUCE: $4

NOTES:
This mine is tripwire-initiated using a pull fuze. Pulling on the tripwire extracts the striker retaining pin, releasing the spring-loaded striker onto the percussion detonator assembly. The resulting mass of shrapnel from the detonated mine body causes death to those in close proximity.

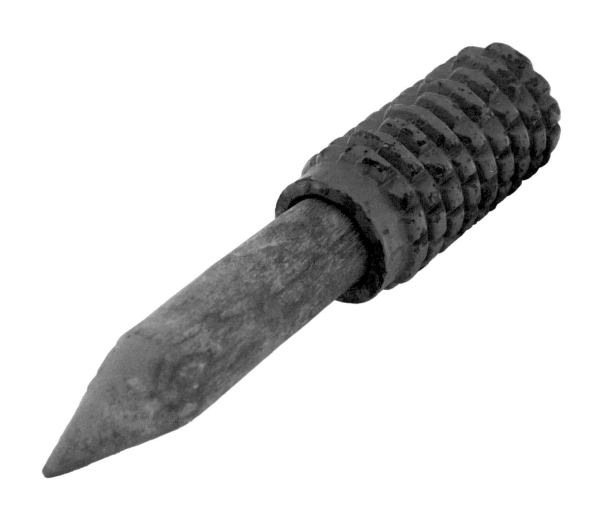

BELOW-ELBOW MYO-ELECTRIC ARM

MANUFACTURER: Touch Bioncs (Scotland/UK)

LIFESPAN: 3-5 years

APPROXIMATE COST TO PRODUCE: $32,000

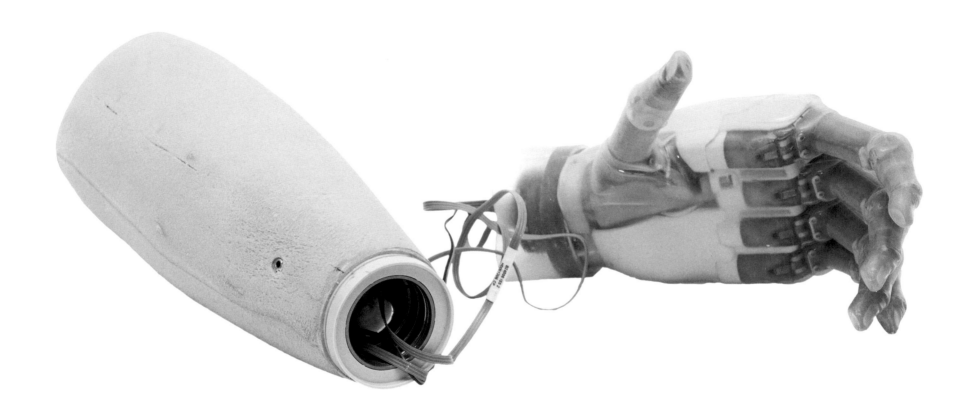

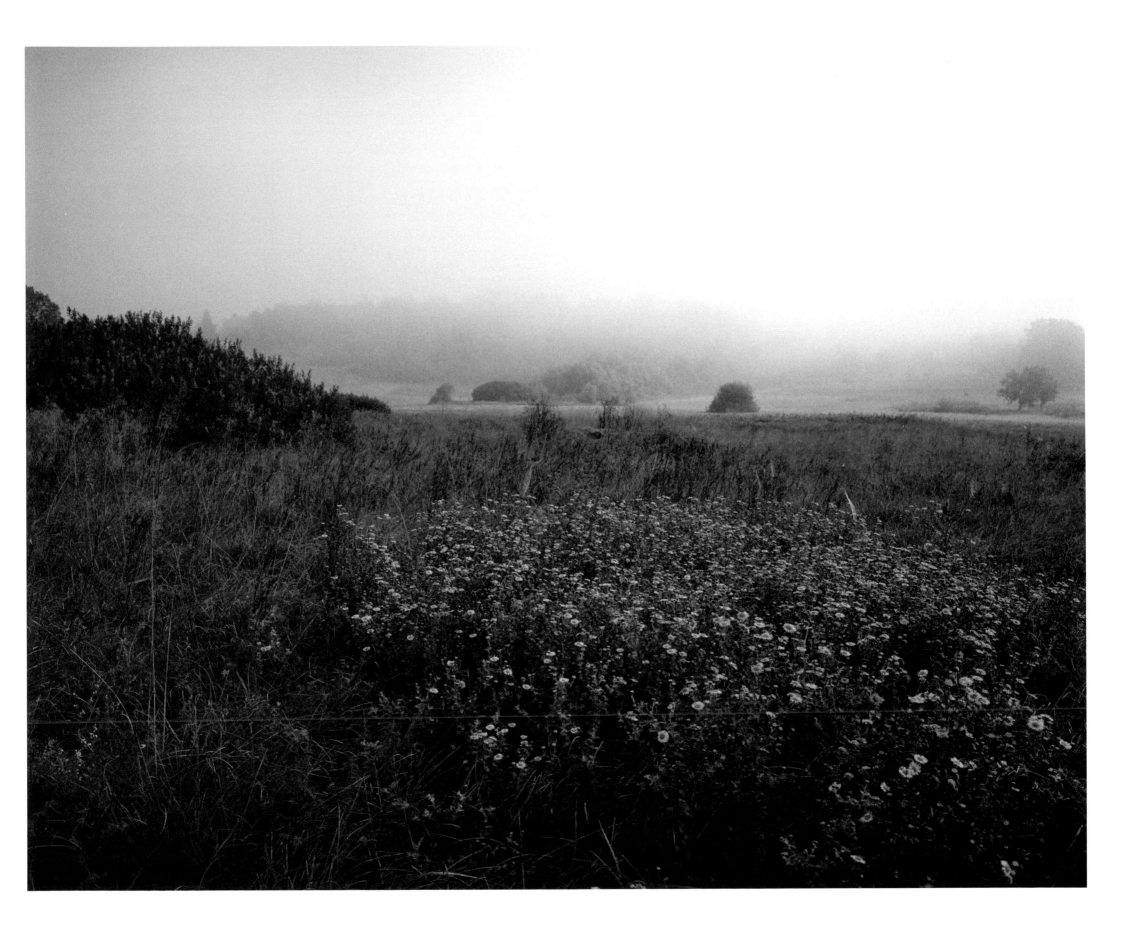

PMA-1

ANTI-MAGNETIC/PLASTIC ANTI-PERSONNEL MINE

MANUFACTURER: Former Yugoslavia

EXPLOSIVE CHARGE: 200 grams TNT

KILL RADIUS: N/A

BLAST RADIUS: N/A

APPROXIMATE COST TO PRODUCE: $3.50

NOTES:
Plastic step mine produces no shrapnel when activated. The 200 grams
of TNT will create a small incineration that will cause the total destruction
of foot and lower leg. Possibility of death from extreme blood loss without
immediate medical attention.

MULTI-AXIAL ENERGY-STORING PROSTHETIC FOOT

MANUFACTURER: College Park Industries (USA)

LIFESPAN: 5 years

APPROXIMATE COST TO PRODUCE: $2,000

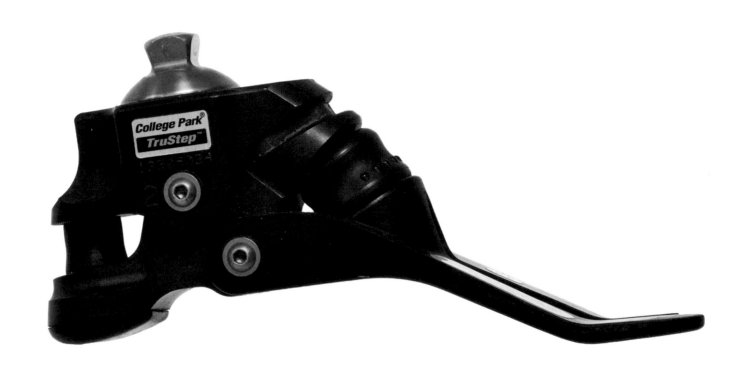

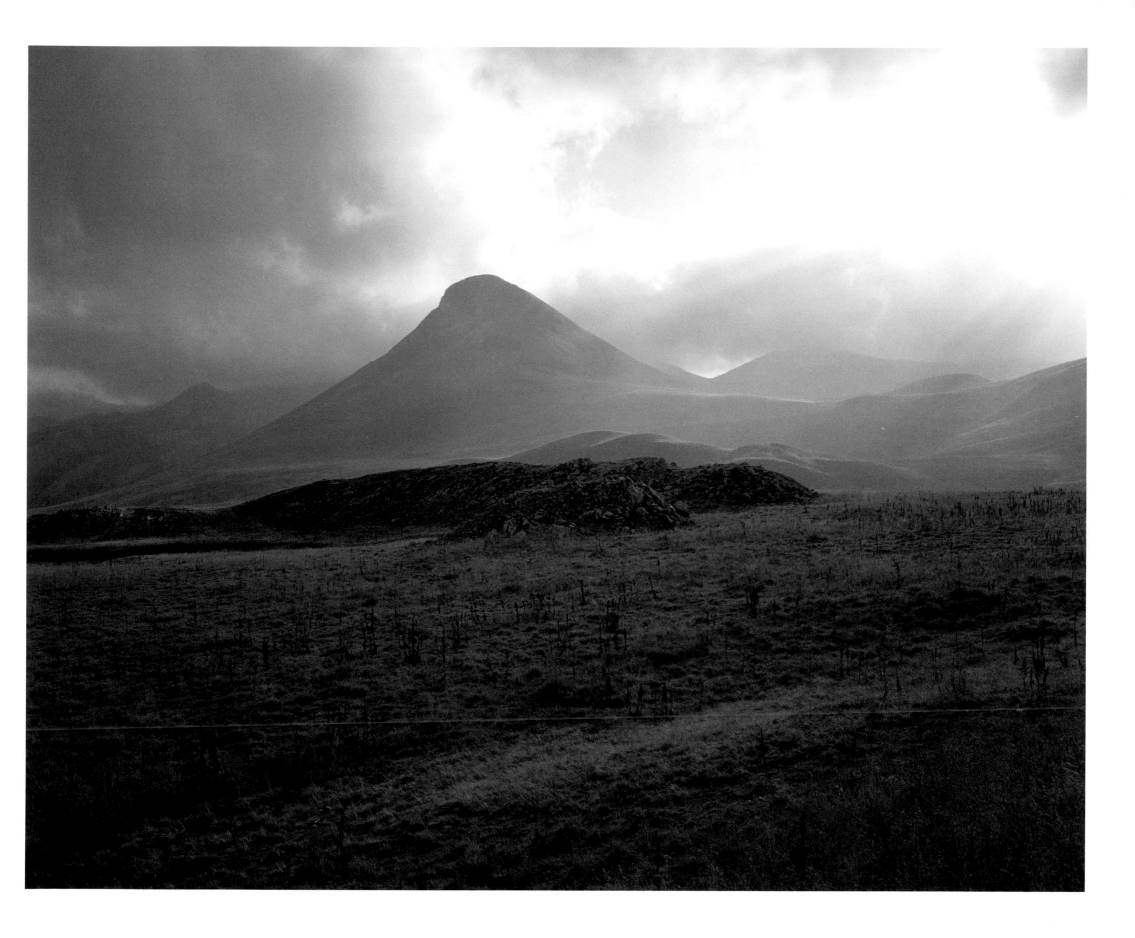

TMRP-6

ANTI-TANK BLAST AND SHAPED-CHARGE MINE

MANUFACTURER: Former Yugoslavia

EXPLOSIVE CHARGE: 5,100 grams TNT

KILL RADIUS: 25 Meters

BLAST RADIUS: 50 Meters

APPROXIMATE COST TO PRODUCE: $8

NOTES:
TMRP-6 expels a convex steel plate to create a self-forming fragment of molten metal. This can penetrate 4 cm of armor at a distance of up to 80 cm. Laid on its side, the mine can be used as a tripwire-activated anti-personnel mine. The molten metal projectile and large-scale incineration can easily cause death.

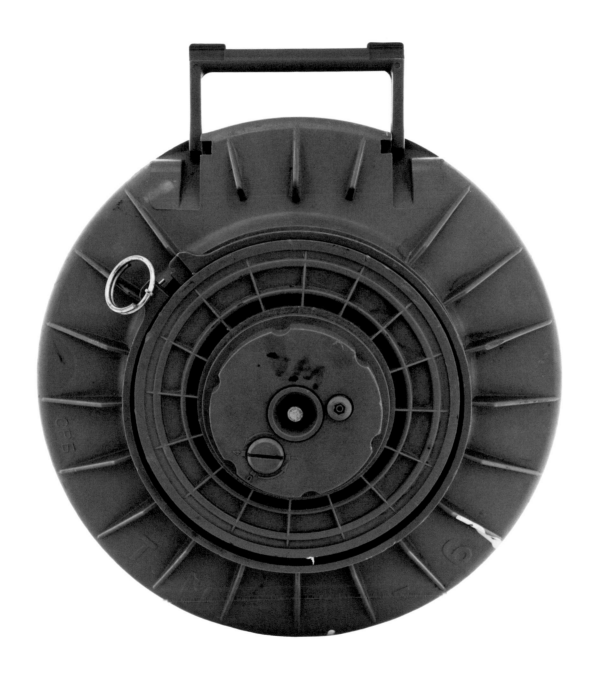

TRIAL VERSION OF ABOVE-KNEE PROSTHETIC LEG

MANUFACTURER: Hybrid of various parts

INTRODUCED: 2010

LIFESPAN: 3-5 years

APPROXIMATE COST TO PRODUCE: $9,600

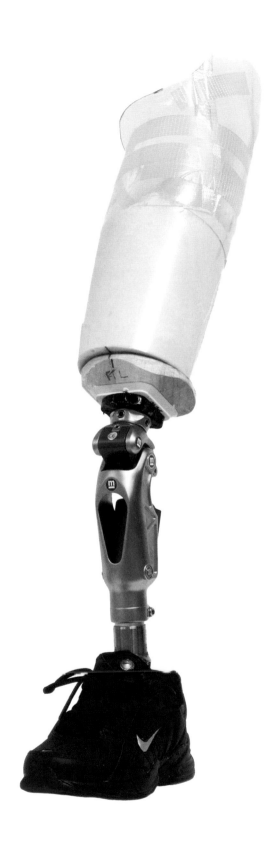

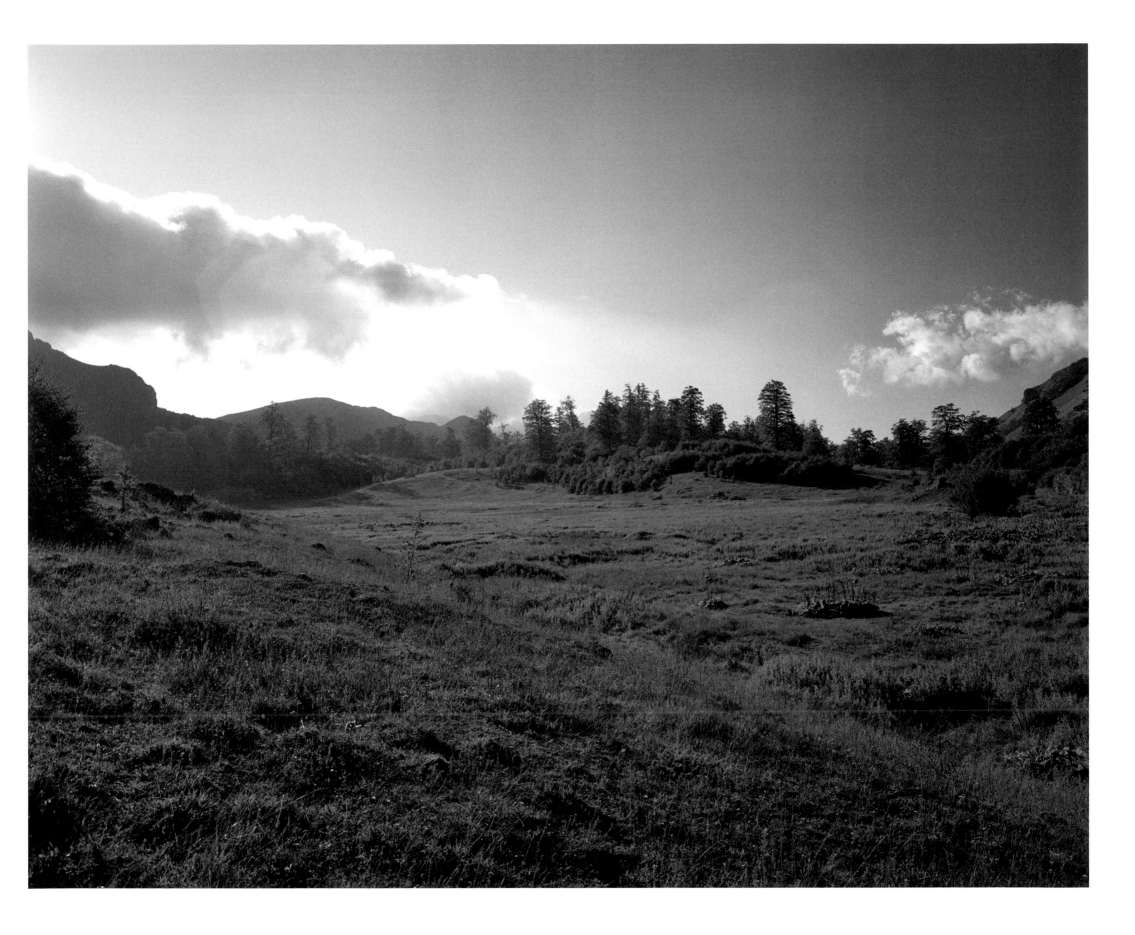

TMA-2

PRESSURE-ACTUATED ANTI-TANK MINE

MANUFACTURER: Former Yugoslavia

EXPLOSIVE CHARGE: 6,500 grams TNT

KILL RADIUS: 40 Meters

BLAST RADIUS: 100 Meters

APPROXIMATE COST TO PRODUCE: $6

NOTES:
The base section of the plastic case contains the main charge. The top section of the casing is ribbed and has two large fuze plugs and a small compartment to store the fuze. Sufficient pressure on the top of the mine collapses the lid and applies pressure to the UANU-1 fuze. The fuze plunger is forced into a friction-sensitive composition to create a flash, which initiates the detonator, booster, and main charge. The base of the mine has an auxiliary fuze well for booby trapping.

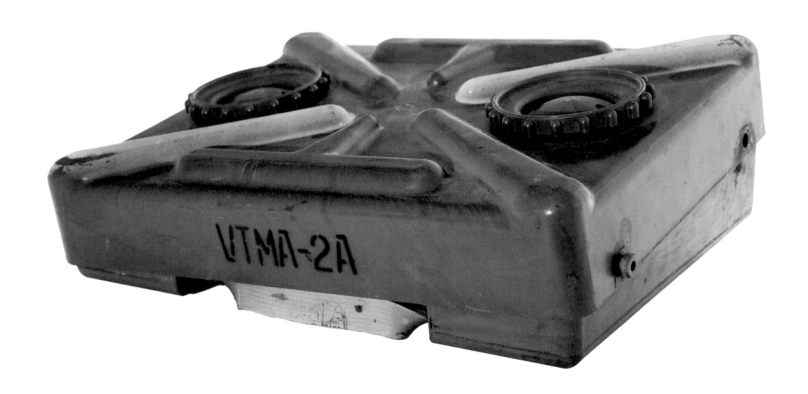

CUSTOM-MADE HIGH-DEFINITION BELOW-KNEE PROSTHETIC LEG COVERING

MANUFACTURER: Steeper (UK)

INTRODUCED: 1998

LIFESPAN: 3 years

APPROXIMATE COST TO PRODUCE: $6,400

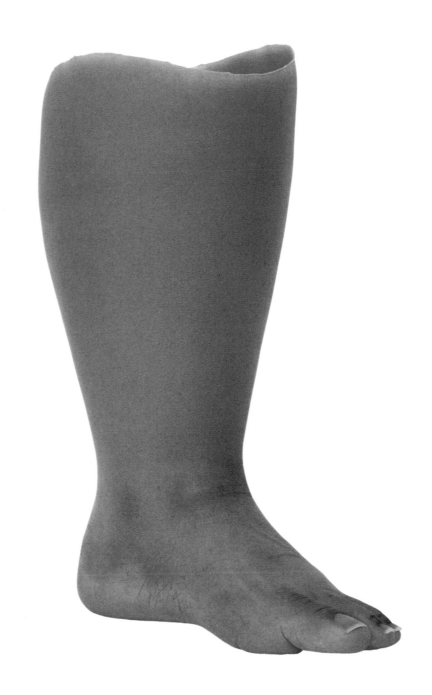

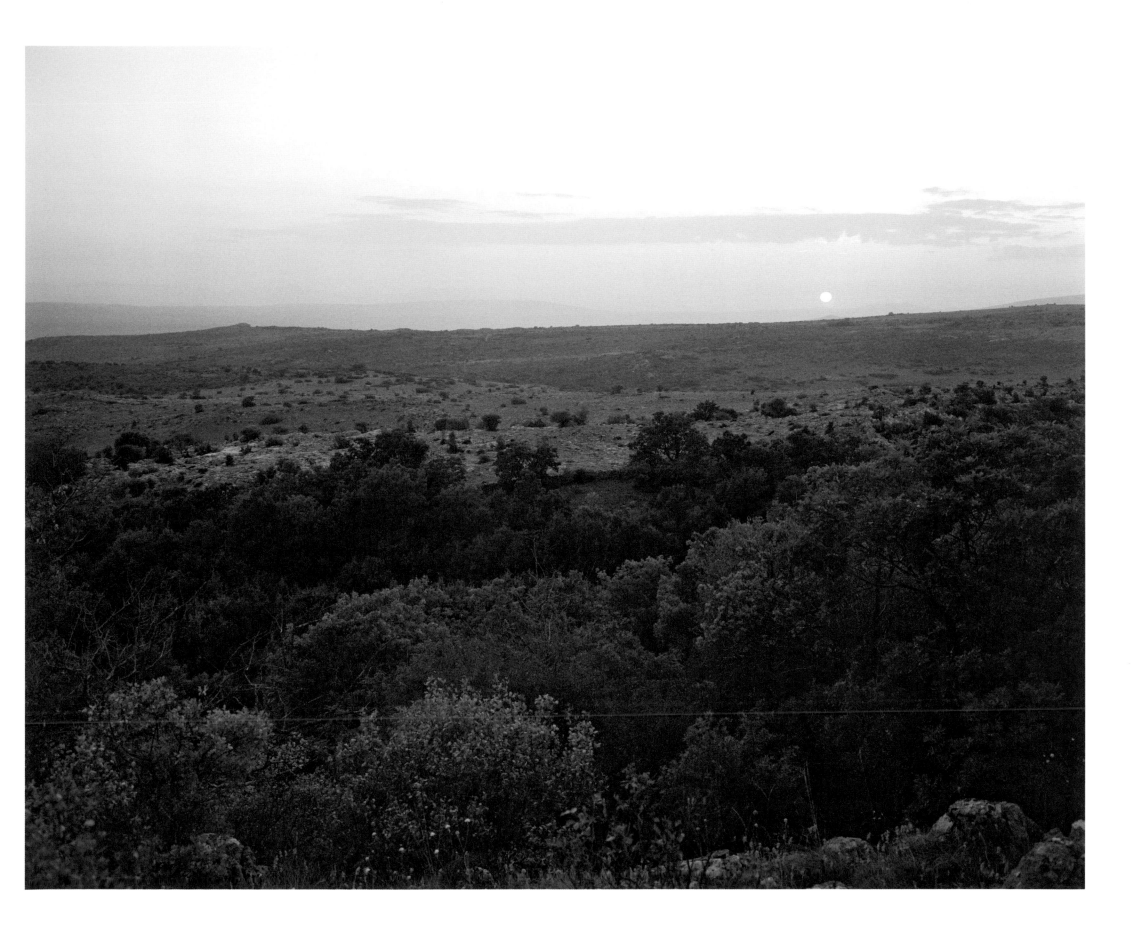

TMA-1

PLASTIC PRESSURE-ACTUATED ANTI-TANK MINE

MANUFACTURER: Former Yugoslavia

EXPLOSIVE CHARGE: 5,488 grams TNT

KILL RADIUS: 30 Meters

BLAST RADIUS: 100 Meters

APPROXIMATE COST TO PRODUCE: $8

NOTES:
Along the body circumference, there are four openings set crosswise for the insertion of joints, designed to regulate the treading force. The UTMAH-1 plastic fuze is used with the mine. The mine is used against tanks, vehicles, and personnel, as well as in demolitions.

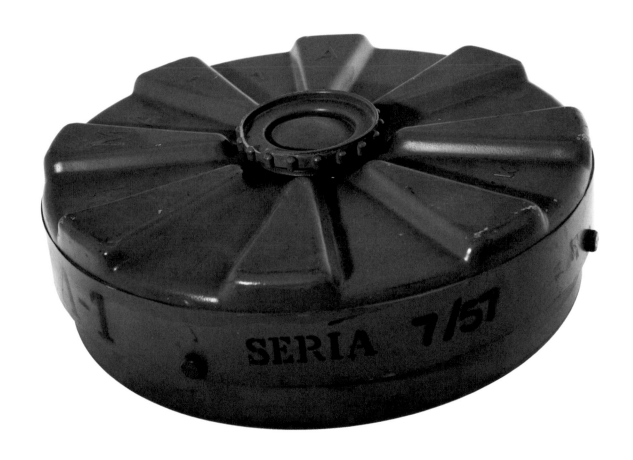

POLYCENTRIC HYDRAULIC KNEE JOINT

MANUFACTURER: Medi (Germany)

INTRODUCED: 2002

LIFESPAN: 5 years

APPROXIMATE COST TO PRODUCE: $3,000

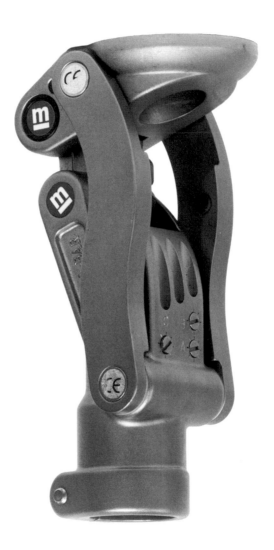

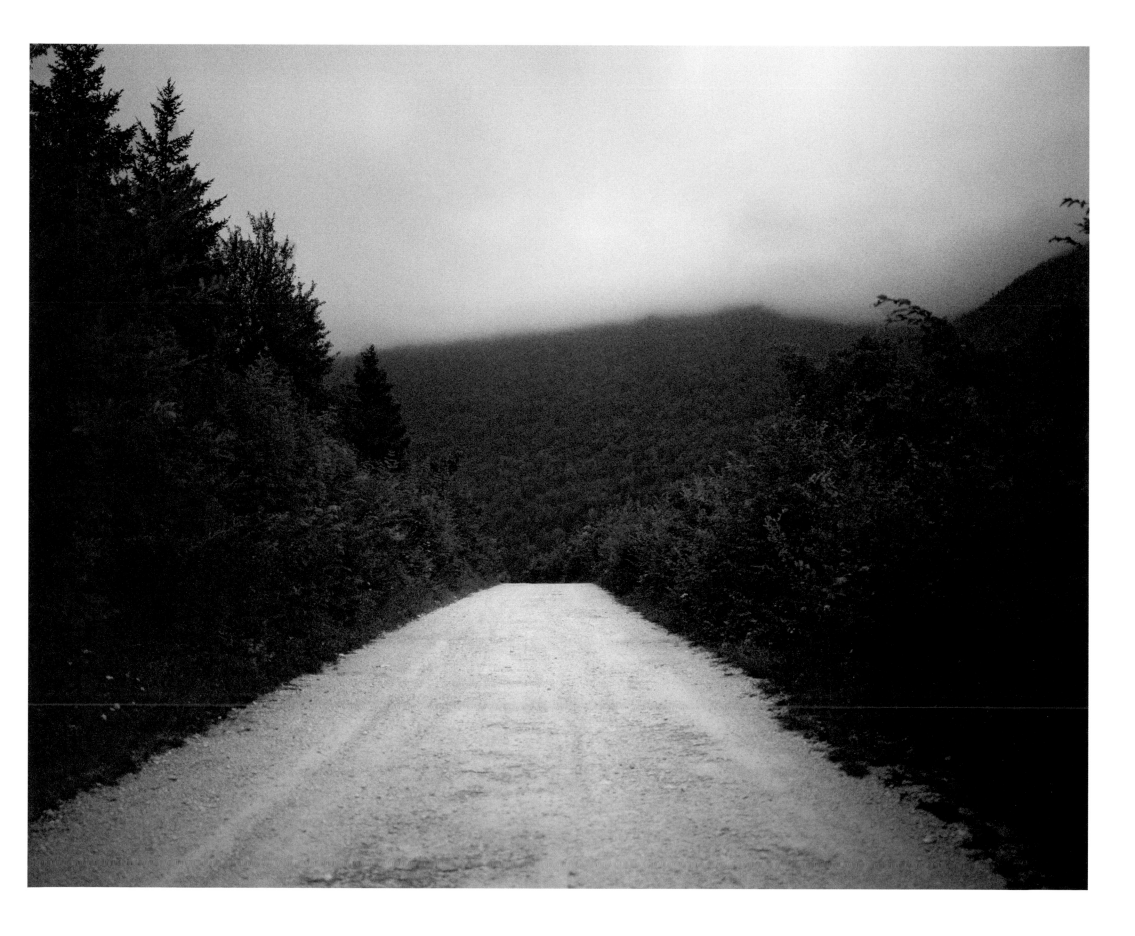

PMR-2

TRIPWIRE-ACTIVATED ANTI-PERSONNEL FRAGMENTATION MINE

MANUFACTURER: Former Yugoslavia

EXPLOSIVE CHARGE: 100 grams TNT

KILL RADIUS: 25 Meters

BLAST RADIUS: 50 Meters

APPROXIMATE COST TO PRODUCE: $4

NOTES:
This mine is tripwire-initiated using a pull fuze. Pulling on the tripwire extracts the striker retaining pin, releasing the spring-loaded striker onto the percussion detonator assembly. The resulting mass of shrapnel from the detonated mine body causes death to those in close proximity.

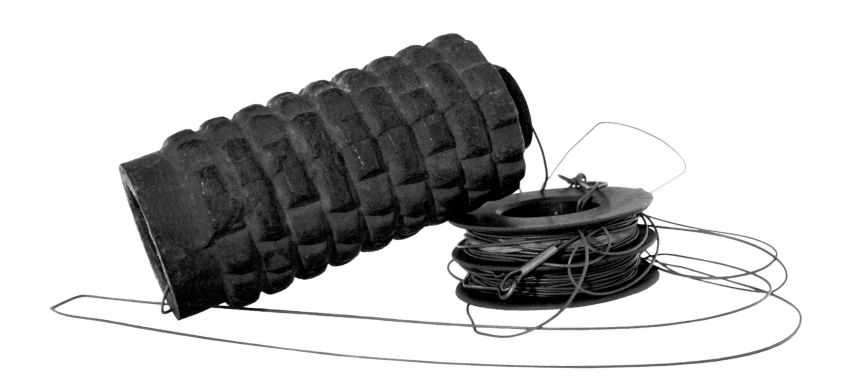

CUSTOM-MADE HIGH
DEFINITION SILICON FINGERS

MANUFACTURER: Steeper (UK)

LIFESPAN: 2 years

APPROXIMATE COST TO PRODUCE: $1,760

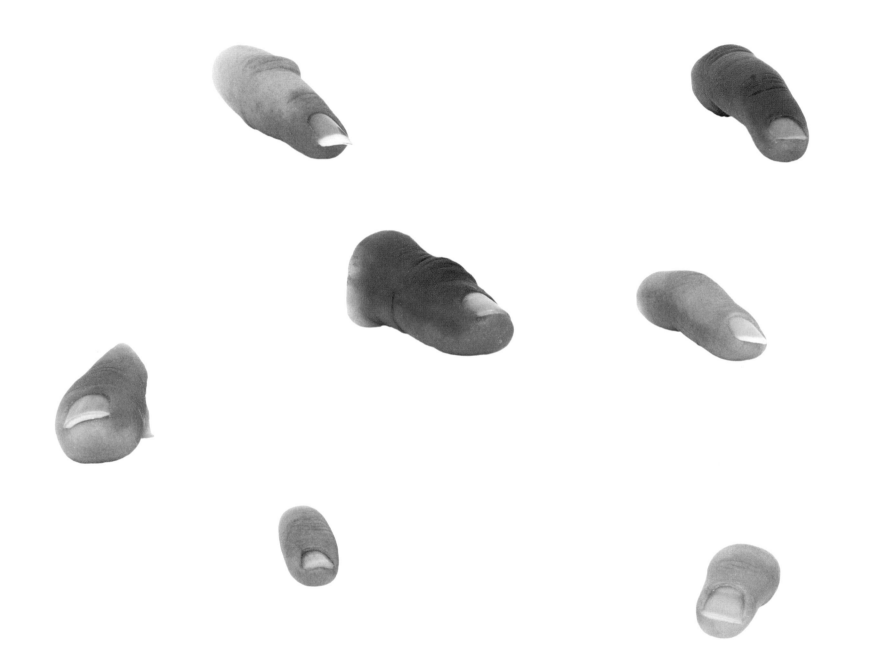

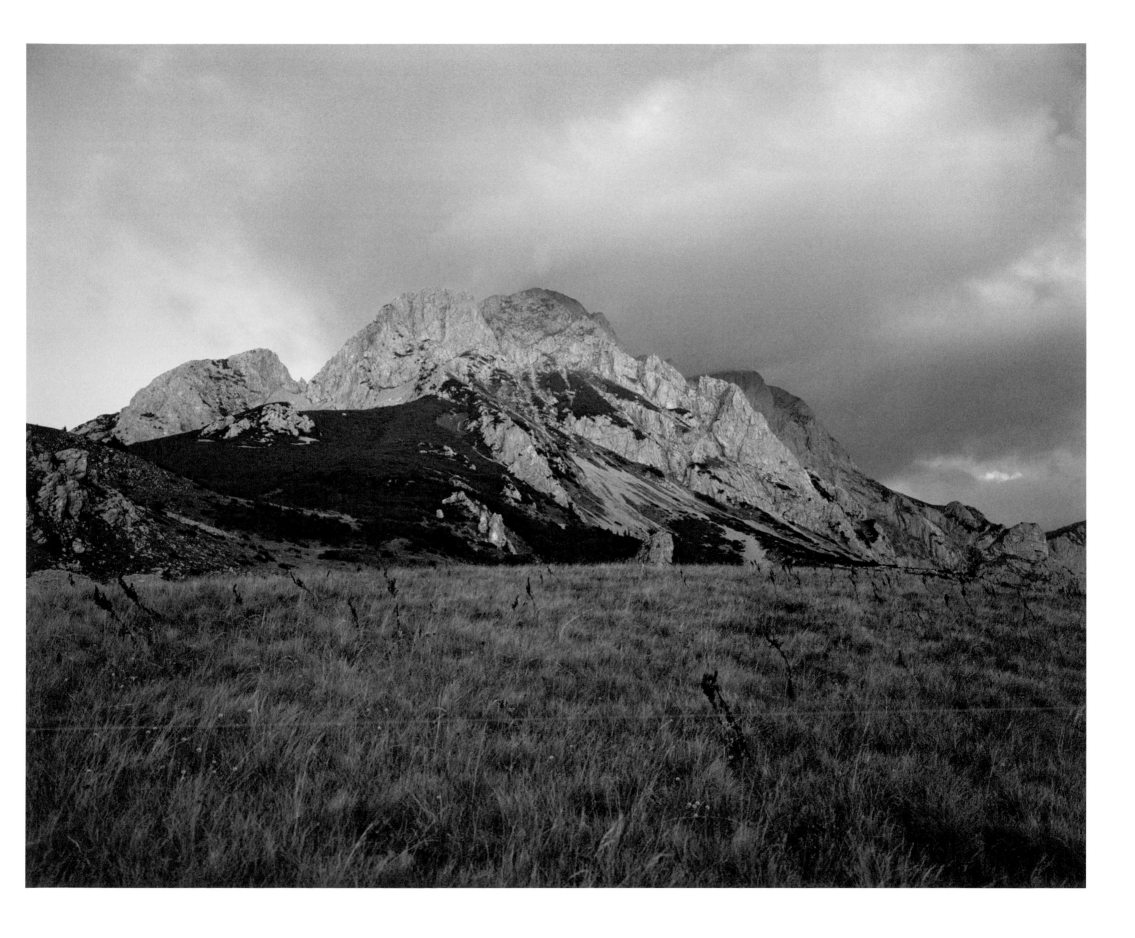

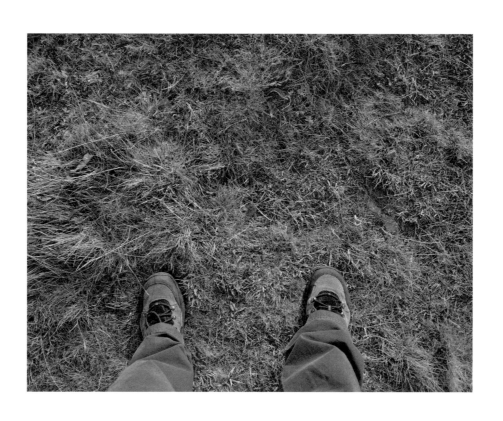

Leftover munitions and landmines from the wars in the early 1990s still litter the countryside in Bosnia and Herzegovina. I traveled there in late 2009 to photograph areas that were once the front lines of the Bosnian War.

I took this photograph of my feet seconds after capturing the image of Mount Maglic on the previous page. The grounds in the area where I took this photograph were free and clear of mines.

The officials in Sutjeska National Park, where Mount Maglic is located, assured me this area was safe to travel through on foot. However, the lower reaches of the peak, below the tree line, were not.

Even though my safety was confirmed, I continued to look down at my feet, as I had been doing in more dangerous places in the previous weeks. In some respects, the picture of Maglic represents my only true interaction with the peak as my attention was constantly diverted to the ground.

I also included this image of my feet as I feel it represents the fear that permeates a populace when the specter of mines has been ever-present for decades after a conflict subsides. Nature temporarily reclaims that which was hers in the aftermath of a conflict. Underneath hide the landmines – random, brutal killing machines.

As an avid hiker and backpacker, raised in an American city, I have always found nature to be easily packaged, conquerable, and pleasurable to roam through and explore. The inherent fear of wilderness in all of us has subsided as we have constructed our urban environment over the past few centuries. I chose to photograph the former front lines of the Bosnian War as a way of challenging this lack of fear. When we are forced to recognize the power of nature, in the form of a natural disaster or, in this case, a man-made disaster; we feel the trepidation our ancestors dealt with on a daily basis.

While working in the fields in Bosnia, I was told by workers from NGO Landmine Survivors Initiative not to wander into rural areas without a guide. Numerous people told me the safest place to be was on a road or on the tarmac. Fourteen years after the conflict ended, caution had to be taken with every step.

As a vast majority of the mining was undocumented or known only to foot soldiers who fought in the areas, many innocent civilians continue to lose their lives. According to the Mine Action Centre for Bosnia and Herzegovina (BHMAC) just over 3.5% of the country was still contaminated by landmines in 2009. Today, as this book goes to press, 2.8% of the country is still considered a minefield.

However, many of the de-miners in the field estimate roughly 10% of the country can still be deemed a landmine area. They feel that nowhere in the countryside is safe as they may clear one area but a torrential downpour may unearth and move landmines. These unearthed landmines find their way into vicinities that were deemed safe weeks, months, or even years ago. BHMAC also continues to find areas at one time considered safe that now require additional de-mining activity.

The landscapes presented in this project depict the mesmerizing beauty of a seemingly untouched landscape as well as the terrifying unknown, the danger that lies beneath the surface. I tried to create a conduit to this sense of terror by meeting with, talking to, and photographing the survivors of landmine explosions.

Although I did not include their photographs in the final edit of the work, I feel that their insight and experience allowed me to feel the weight and emotion that touches so many people's lives in Bosnia and Herzegovina. How does it feel to live in an area of the world where nature still holds a primordial sense of fear? If I had photographed the landscapes without talking to those who were injured in these areas, the photographs, I feel, would have been missing their connections to humanity.

This work displays the regenerative power of nature and the devastating effect that landmines inflict on a populace. Human beings have an almost insatiable appetite to expand, explore, conquer, and transform nature into civilization. Ironically, in this instance, it is a man-made killing machine that keeps the setting in its natural state.

For the survivors, and the families of lost ones…

Brett Van Ort

CAPTAIN JASIM MAHMUTOVIC, *2nd Corps of the Army of Bosnia and Herzegovina*

I met, interviewed, and photographed Jasim Mahmutovic while traveling between Tuzla and Doboj with the local NGO Landmine Survivors Initiative. The general vicinity where Jasim was injured is shown on page 14—Majevica, near to where the interview took place. I interviewed Jasim on August 13, 2009.

On 27 June 1993, I stepped on the mine. I was primarily an electrician prior to the war and my injury.

It's not easy to go back and talk about what happened to me, but I'm also not able to run away from it… so…

When it came to war no one asked us if we wanted to go to war or not. About 1km from here were the front lines and where I lost my leg. And it's a highly mined area…still to this day. It was a highly contested area. We had to walk all the way through these mined areas to get to the front lines. We had no transportation to do this so we walked.

The area I was in when I was injured, I was marching downhill. I stepped on a piece of wood or a tree branch… I can't remember other than I heard a crack and then everything was hot in my leg… This branch was next to and on top of the mine. Basically the main explosion went mainly to my foot. My left foot. It completely removed my entire heel bone and most of the back of my ankle and Achilles tendon. I think it was a PMA-2 mine with TNT and iron pieces from what I could tell.

I had to be carried out of the area by two other people I was with. This is what these particular mines do. They do not kill people, but injure them so much that I needed help to come off of the mountain. Then instead of one person being taken out of battle, my two friends are as well.

I spent so much time in the hospitals because my heel and foot were damaged originally but then my back and spinal cord were also hurt. Being in many different hospital beds for more than several months during the war didn't help. I had so many problems with the muscles in my legs and all the way up my spine. During the time that I was in the hospital I also had surgery on my spinal cord.

It took me about a year to recover fully from the injury.

I still have problems with my back, because of the injury to my spinal cord. I have since developed diabetes, which I have to take insulin for. I was depressed for years after the war and still deal with post-traumatic stress disorder.

As far as my injuries themselves, they can never be healed for good. My leg still swells. Cracks show in my leg and bleed, and I have pain for several days afterwards. After going to a doctor they can fix it but only for the time being. After a couple of months I go through this entire process all over again.

These injuries will always be here for the rest of my life and will be a reminder of what has happened.

THE OTTAWA TREATY

Convention on the Prohibition of the Use, Stockpiling, Production and Transfer of Anti-Personnel Mines and on their Destruction

The States Parties,

Determined to put an end to the suffering and casualties caused by anti-personnel mines, that kill or maim hundreds of people every week, mostly innocent and defenceless civilians and especially children, obstruct economic development and reconstruction, inhibit the repatriation of refugees and internally displaced persons, and have other severe consequences for years after emplacement,

Believing it necessary to do their utmost to contribute in an efficient and coordinated manner to face the challenge of removing anti-personnel mines placed throughout the world, and to assure their destruction,

Wishing to do their utmost in providing assistance for the care and rehabilitation, including the social and economic reintegration of mine victims,

Recognizing that a total ban of anti-personnel mines would also be an important confidence-building measure,

Welcoming the adoption of the Protocol on Prohibitions or Restrictions on the Use of Mines, Booby-Traps and Other Devices, as amended on 3 May 1996, annexed to the Convention on Prohibitions or Restrictions on the Use of Certain Conventional Weapons Which May Be Deemed to Be Excessively Injurious or to Have Indiscriminate Effects, and calling for the early ratification of this Protocol by all States which have not yet done so,

Welcoming also United Nations General Assembly Resolution 51/45 S of 10 December 1996 urging all States to pursue vigorously an effective, legally-binding international agreement to ban the use, stockpiling, production and transfer of anti-personnel landmines,

Welcoming furthermore the measures taken over the past years, both unilaterally and multilaterally, aiming at prohibiting, restricting or suspending the use, stockpiling, production and transfer of anti-personnel mines,

Stressing the role of public conscience in furthering the principles of humanity as evidenced by the call for a total ban of anti-personnel mines and recognizing the efforts to that end undertaken by the International Red Cross and Red Crescent Movement, the International Campaign to Ban Landmines and numerous other non-governmental organizations around the world,

Recalling the Ottawa Declaration of 5 October 1996 and the Brussels Declaration of 27 June 1997 urging the international community to negotiate an international and legally binding agreement prohibiting the use, stockpiling, production and transfer of anti-personnel mines,

Emphasizing the desirability of attracting the adherence of all States to this Convention, and determined to work strenuously towards the promotion of its universalization in all relevant fora including, inter alia, the United Nations, the Conference on Disarmament, regional organizations, and groupings, and review conferences of the Convention on Prohibitions or Restrictions on the Use of Certain Conventional Weapons Which May Be Deemed to Be Excessively Injurious or to Have Indiscriminate Effects,

Basing themselves on the principle of international humanitarian law that the right of the parties to an armed conflict to choose methods or means of warfare is not unlimited, on the principle that prohibits the employment in armed conflicts of weapons, projectiles and materials and methods of warfare of a nature to cause superfluous injury or unnecessary suffering and on the principle that a distinction must be made between civilians and combatants.

SIGNATORIES:

Afghanistan
Albania
Algeria
Andorra
Angola
Antigua and Barbuda
Argentina
Australia
Austria
Bahamas
Bangladesh
Barbados
Belarus
Belgium
Belize
Benin
Bhutan
Bolivia
Bosnia and Herzegovina
Botswana
Brazil
Brunei Daressalam
Bulgaria
Burkina Faso
Burundi
Cambodia
Cameroon
Canada
Cape Verde
Central African Republic
Chad
Chile
Colombia
Comoros
Congo, Democratic
 Republic of
Congo, Republic of
Cook Islands
Costa Rica
Cote d'Ivoire
Croatia

Cyprus
Czech Republic
Denmark
Djibouti
Dominica
Dominican Republic
Ecuador
El Salvador
Equatorial Guinea
Eritrea
Estonia
Ethiopia
Fiji
Finland
France
Gabon
Gambia
Germany
Ghana
Greece
Grenada
Guatemala
Guinea
Guinea-Bissau
Guyana
Haiti
Holy See
Honduras
Hungary
Iceland
Indonesia
Iraq
Ireland
Italy
Jamaica
Japan
Jordan
Kenya
Kiribati
Kuwait
Latvia

Lesotho
Liberia
Liechtenstein
Lithuania
Luxembourg
Macedonia
Madagascar
Malawi
Malaysia
Maldives
Mali
Malta
Mauritania
Mauritius
Mexico
Moldova, Republic of
Monaco
Montenegro
Mozambique
Namibia
Nauru
Netherlands
New Zealand
Nicaragua
Niger
Nigeria
Niue
Norway
Palau
Panama
Papua New Guinea
Paraguay
Peru
Philippines
Portugal
Qatar
Romania
Rwanda
Saint Kitts and Nevis
Saint Lucia

Saint Vincent and
 Grenadines
Samoa
San Marino
Sao Tome and Principe
Senegal
Serbia
Seychelles
Sierra Leone
Slovakia
Slovenia
Solomon Islands
Somalia
South Africa
South Sudan
Spain
Sudan
Suriname
Swaziland
Sweden
Switzerland
Tajikistan
Tanzania
Thailand
Timor-Leste
Togo
Trinidad and Tobago
Tunisia
Turkey
Turkmenistan
Tuvalu
Uganda
Ukraine
United Kingdom
Uruguay
Vanuatu
Venezuela
Yemen
Zambia
Zimbabwe

NON-SIGNATORIES:

Armenia
Azerbaijan
Bahrain
Burma
China
Cuba
Egypt
Georgia
India
Iran
Israel
Kazakhstan
Korea, Democratic People's Republic of
Korea, Republic of
Kyrgyzstan
Lao PDR
Lebanon
Libya
Marshall Islands *(signed, but not ratified)*
Micronesia
Mongolia
Morocco
Nepal
Oman
Pakistan
Poland *(signed, but not ratified)*
Russian Federation
Saudi Arabia
Singapore
Sri Lanka
Syria
Tonga
United Arab Emirates
United States
Uzbekistan
Vietnam

ACKNOWLEDGEMENTS

I would first like to honor the memory of Stephen Dickter. You told me to follow my dreams. I thank you, my dear friend, and I will miss you. I am also so fortunate to have the love, strength, and support of my parents, Dale and Molly Van Ort. And to my wife Eleanor Infante, you are my North Star. Thank you for your love, patience, and guidance.

Thank you to those of you who supported or encouraged this project along the way. Without the help of these people and organizations it would have been exceptionally difficult for me to get to this point: Torrey Acri, Felicia Anastasia, Barby Asante, Polly Beale, Jen Berry, Mica Bevington, Bosnia Herzegovina Mine Action Centre, Aaron Buckley, Louis Max Buju, Lila Byall, Ray Cams, Alejandro Cartagena, CENTER, Nerina Cevra, Gabrielle Chaizy, Marcia Chandra, Giacomo Cimi and Sonia Goncalves, Louise Clements and FORMAT International Photography Festival, Scott Clendenin, Gary and Jean Cohen, Ursula Damm, Lucy Davies, Michael DiBenedetto, Jacqui and Georgina Dickinson, Scott and Rachelle Doorley, the Dupont family, John Easterby, Scott Fleming and Chris Winter, Peter Fraser, Clare Gillmore, Abdo S. Haidar, Handicap International, Daniel Hanych, Harry Hardie, Emmylou Harris, Lauren Hollingsworth and family, Vivienne Infante, Sharon Infante-LoParo and Joe LoParo, Tito, Crissie Jamieson and Babette, Ed Kashi, Gloria LaMont, Allan Little, Paul Lowe, Kay and Gene Lunceford, Jasim Mahmutovic, Miroslav Mandaric, Clair Marlo, Jason R. Martinez, Stephen Mayes, Michael McCurdy and Christa Van Alstine, Pat and Nina McKay, Jarred Metze and Mariko Ishihara Metze, Andrea Teague Mueller, Aladin Mujacic, Amir Mujanovic, Anne Mullen, Mark Mullen, Michelle Newell, Brandon and Lila Newton, Simon Norfolk, Justin Painter, Zoran Panic, Jason Pedroza, Elizabeth Petty and Karen Milner, Julie Pittman and Jeremy Rosenberg, Duncan Robertson, Linda Salazar, Dolph Scott, Tom Sempre and Photo Alliance, Dan Shepherd, Shasta Spahn, Todd Stanley, Stephanie Stuart, Svjetlana Trifkovic, United Nations Mine Action Service, United Nations Development Programme, Doug and Joann Van Ort, Santiago Vanegas, Clara Veselica, David Wagreich, Rhonda Wilson, Jonas Yip, and whomever else I may have forgotten.

A special thank you is in order for Michael Itkoff and Taj Forer, who believed a great book could be made. Without them, I am sure you would not be reading this.